calligraphy
AND LETTERING DESIGN

BY ART NEWHALL

WALTER FOSTER Publishing, Inc.
430 West Sixth St., Tustin, CA 92680-9990

Contents

Introduction

The tremendous interest and popularity of calligraphy among the general public in recent years has increased the scope and the use of this beautiful lettering form. Aside from its obvious place in the production of diplomas, awards, testimonials and verses; a contemporary use of calligraphy has developed, creating a new, exciting demand for it in the design of logos, movie titles, book jackets, album covers, sign design, menus, labels, posters, type design and advertising — to name just a few.

This book offers the reader a comprehensive reference guide and study manual. It presents a myriad of alphabets and their applications to study and to copy. Beginners should always have good examples in front of them while practicing. More advanced calligraphers can use the letter style samples for reference.

It is imporant to first learn the basics and to become comfortable with your tools, but try to be adventurous and creative. Practice with different pens, papers and techniques. Develop your own styles of lettering or change established letter styles to make them your own.

Materials

PENS AND INK

Calligraphic lettering is done primarily with a broad pen. There are two types of broad pens: dip pens and fountain pens. Both have interchangeable nibs. There are many brands on the market. The main advantage of fountain pens is their ability to hold a large supply of ink, but they have a limited number of nib sizes and do not utilize permanent ink. Dip pens produce a cleaner, crisper line than fountain pens, but are slightly more difficult to master. You will need a jar of black india ink for use with a dip pen. It is very important to keep both types of pens clean. A small jar of water kept nearby for dipping the pen and wiping it clean is recommended.

The Broad Pen is available in a variety of shapes and sizes.

Fine Point Nibs for detail lettering.

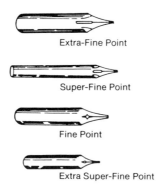

Extra-Fine Point

Super-Fine Point

Fine Point

Extra Super-Fine Point

A wide, small jar secured to a piece of heavy card or plastic keeps the ink container stable. The ink level should be just high enough for a dipped pen load.

Materials

PAPER

There are many types of paper and boards suitable for calligraphy. The choice depends on the quality and type of work you are doing. A 20 lb. ledger bond is good for practice. For all-purpose lettering, 100% rag bristol board is favored. Bristol board comes in two finishes, kid and plate. The kid finish is the better of the two as it has a slight "tooth." For the final "one of a kind" job, a parchment paper made specifically for calligraphy is available. Show card board also takes ink beautifully. Give it a try.

MISCELLANEOUS

Your equipment can be quite simple or very extensive. A drawing table (about 30" x 40"), a chair and a good source of light are a must if you are serious about your work. You will also need a t-square, several triangles — 30, 45, and 60 degree angles — and pencils, pens, pen cleaner, erasers, a pencil sharpener, ink, opaque white paint (for correcting mistakes) and a few lettering brushes.

Basic Instruction

Calligraphic lettering is done with the broad pen. The angle the pen is held is the key to the beautiful "thick and thin" style. A simple, basic letter style that is quite easy to execute with the broad pen is shown on page 7. The letter is a thick and thin Roman style without serifs. This style is beautiful and practical. It is sometimes called "Stunt Lydian" because it is similar to the Lydian type face. The pen is held fairly rigid, pointing above the right shoulder, held at a 35 degree angle. The vertical (down) strokes and the horizontal strokes are made with a firm wrist action. The pen is held at a constant angle — never rotated.

Use quality bond paper for practice. It takes ink beautifully, and is relatively inexpensive. Using your t-square, draw guidelines on a sheet of smooth illustration board, then place it underneath a sheet of bond paper. (This eliminates having to draw guidelines on each piece of bond paper.) Always keep a small piece of card or scrap paper nearby to check the ink flow of your pen. After each dip of the pen, pull a short stroke on the card to remove the excess ink. This is very important as too much ink creates a sloppy line.

Try using different pen angles to acquaint yourself with the results. Constant practice is a must, and it is important to have good copy in front of you for reference. Also, be sure to clean your pen frequently —dip it in a jar of water and wipe it clean with a lint-free rag. At the end of a session, clean the nib with pen cleaner — ammonia works fine.

SPACING — The spacing between letters is as important as the letters themselves. Good spacing involves equalizing the optical weight or smoothness of the word. In upper case letters the narrowest space is between round letters such as O and C. A slightly wider space is between a straight letter and a round letter, like I and O. The widest space is between two straight, vertical letters such as H and I. Diagonal letters are spaced optically to equalize the open area; no dark or light sections should dominate. Proper spacing is called "good color."

Basic
Sans Serif Style

ABCDEFGHI
JKLMNOPQ
RSTUVWXY
Z

CAPITAL HEIGHT
8 PEN WIDTHS

BODY OF LOWER CASE 5 PEN WIDTHS

Ascenders & Descenders
3 Pen Widths

abcdefghi
jklmnopqr
stuvwxyz

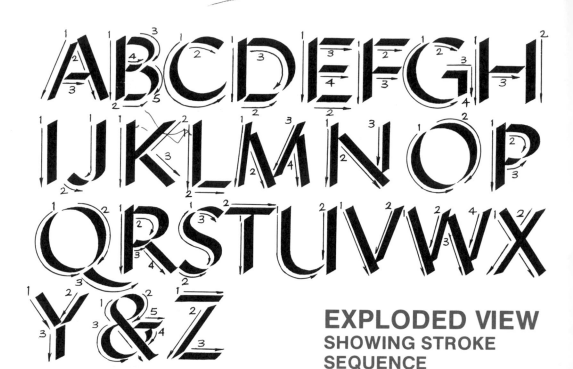

ABCDEFGH
IJKLMNOP
QRSTUVWX
Y&Z

EXPLODED VIEW
SHOWING STROKE
SEQUENCE

abcdefgh
ijklmnopq
rstuvwx
yz

8

Numerals

123456789

123456789

123456789

123456789

123456789

Chancery Cursive

The Chancery letter is a favorite with calligraphers because of its beauty, function and speed of execution. It is great for a large amount of copy.

The Chancery Cursive (italic) letter lends itself beautifully to the broad pen. The shape of the letters are tall rather than fat. The pen angle is 45 degrees, but the pitch of the stroke is 10-15 degrees off the vertical. The pen does most of the work and little pressure is needed. Use one of the larger nibs for practice as they are much easier to control. Follow the stroke sequence as shown. Use the guideline board for practice.

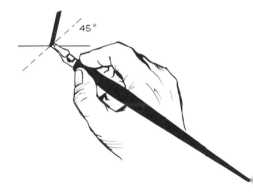

45°

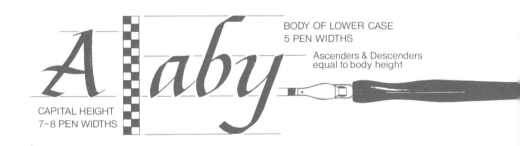

BODY OF LOWER CASE
5 PEN WIDTHS

Ascenders & Descenders
equal to body height

CAPITAL HEIGHT
7-8 PEN WIDTHS

10

STROKE SEQUENCE

UPPER
CASE
LETTERS

LOWER
CASE
LETTERS

ABCDE
FGHIJ
KLMN
OPQRS
TUVW
XYZ&

CHANCERY CURSIVE

abcdefgh
ijklmno
pqrstuv
wxyz

Chancery

CHANCERY CURSIVE

abcdefgh
íjklmno
pqrstuv
wxyz

Cursive

14

ABCDEFG
HIJKLMN
OPQRSTU
VWXYZ

abcdefghijkl
mnopqrstu
vwxyz
Basic

CHANCERY CURSIVE

abcdef
ghijkl
mnop
qrstu
vwxyz
&

CHANCERY CURSIVE

abcdefg
hijklmn
opqrstu
vwxyz

CHANCERY CURSIVE

abcdefghi

jklmnop

qrstuvw

xyz great

CHANCERY SAMPLES

cordially extends an

Invitation

Certificate of Membership

in Recognition

uncial

![uncial]

INSTRUCTION

The name "Uncial" is derived from the Roman inch of height — "*uncia*."

Uncial is an upper case alphabet, but its ascenders and descenders give it an upper and lower case look.

The Uncial letter form is made with a pen angle of 35 degrees. The letters are full and rounded with considerable open areas, so be careful not to overspace. Uncial should feel that it can be contained between two guidelines. The alphabet can be used in a variety of heights and widths. It blends well with italic alphabets.

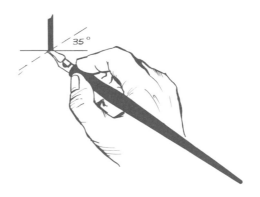

ENVELOPE ADDRESSING GUIDE

Perfectly spaced straight line addresses are as easy as 1-2-3 when you use this handy guide for inner and outer envelopes.

1. Insert addressing guide in the envelope to be addressed with the dark lines facing the flap.

2. Move the guide to the area you wish to address. Once inserted the lines will become visible.

3. Address the envelope using the appropriate lines as a guide.

UNCIAL

ABCDE
FGHYK
LMNOP
QRSTU
VWXY
Z uncial

UNCIAL

ABCDE
FGHIJK
LMNOP
QRSTU
VWXY
Z&!?$

FLOURISHES & SWASHES

This "stylish extra" serves a double purpose by enhancing the space and adding unexpected interest.

It is important that these strokes be executed with discipline and planning. The bold ribbon swash is done with the same broad pen used for the lettering. A smaller pen is used for narrower swashes and a fine point pen is used for hairline flourishes.

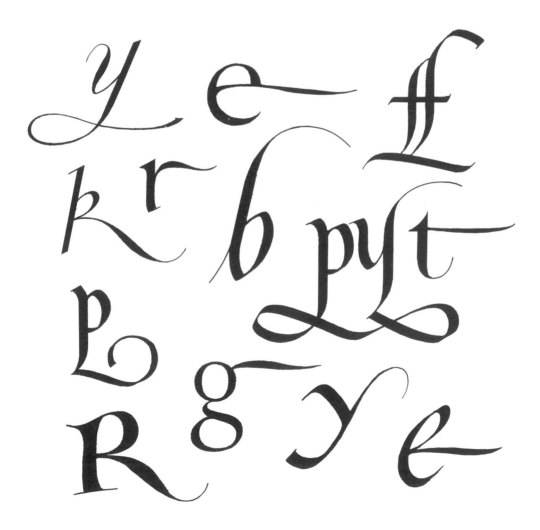

the Black Letter

INSTRUCTION

The Black Letter, also called "Old English," is a handsome, strong, condensed style. It is a great form for creating a feeling of times past. Today, it is often used for diplomas, awards and other certificates.

The Black Letter alphabet has many styles and weights. The basic solid weight letter is not as difficult as it appears because the letters are quite uniform. The pen is held at a 30 degree angle. The very ornate Old English with hairline flourishes must be drawn carefully with a sharp, hard pencil, then inked in with a pointed pen.

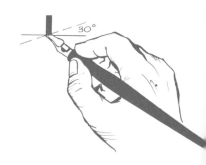

24

BLACK LETTER

A B C D E

F G H I J

K L M N

O P Q R

S T U V

W X Y Z

BLACK LETTER

A B C D E
F G H I J
K L M N
O P Q R
S T U V
W X Y Z

26

BLACK LETTER

ABCDE
FGHIJ
KLMN
OPQRS
TUVW
XYZ

BLACK LETTER

ABCDE
FGHIJ
KLMN
OPQR
STUV
WXYZ

BLACK LETTER

abcdefghi
jklmnopq
rstuvwxy
z

abcdefghi
jklmnopq
rstuvwxy

The CLASSIC ROMAN *Letter*

INSTRUCTION

The Roman letter is the foundation of many of the letter forms used today. Roman stone cutters and scribes developed the classic form. There are many variations of the Roman letter, but the basics remain unchanged.

The Roman capitals are made with a pen angle of 30 degrees. The serifs on the letters are executed by first making an almost horizontal stroke across the top and the bottom of the letter. Then the pen is arced to the right and to the left to finish the serif. A short vertical stroke is made to finish letters C, E, F, G, L, T, and S, then filled in. The detailed, precise classic letters are carefully drawn and inked in with a fine pen.

SERIF DETAILS
AND SEQUENCE

ABCDE
FGHIJK
LMNOP
QRSTU
VWXY
Z & ROMAN

ABCDEF
GHIJKLM
NOPQRS
TUVWX
YZ ROMAN

ROMAN

ABCDE
FGHIJK
LMNOP
QRSTU
VWXYZ

ROMAN — STYLIZED

ABCD
EFGHI
JKLM
NOPQ
RSTU
VWX
Y & Z

abcdef

ghijklm

nopqrs

tuvwx

yz

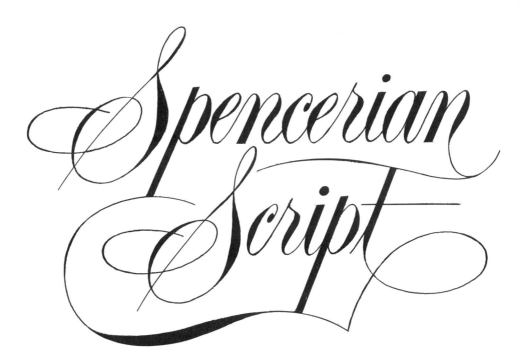

INSTRUCTION

This classy script, also known as "Copperplate" or "Roundhand," is ideal for awards, diplomas, testimonials, greeting cards or whenever a sophisticated feeling is desired.

COPPERPLATE — The intricate single stroke letter is written at a slant of 54 degrees with a flexible, pointed, oblique pen. Copperplate is developed with pressure on the nib. The pressure is gradually increased from a hairline to a swell, then decreased back to a hairline.

SPENCERIAN — Used for captions, logos and nameplates, Spencerian is practical and beautiful. The copy is carefully laid out on tracing paper with pencil, somewhat oversize. When the lettering is accurate, it is transferred to illustration board and inked in carefully with a pointed pen. Correct any slips with opaque white paint and it's ready for photo reduction.

Oblique
Pen

Fine Point
Pen

SPENCERIAN

A B C D E
F G H I J K
L M N O
P Q R S T
U V W X
Y Z *Spencerian*

SPENCERIAN

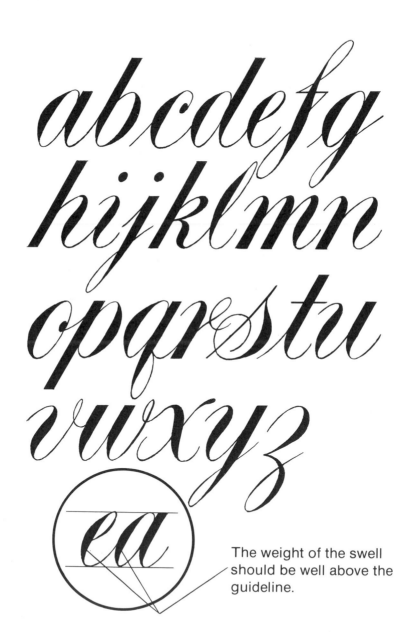

The weight of the swell should be well above the guideline.

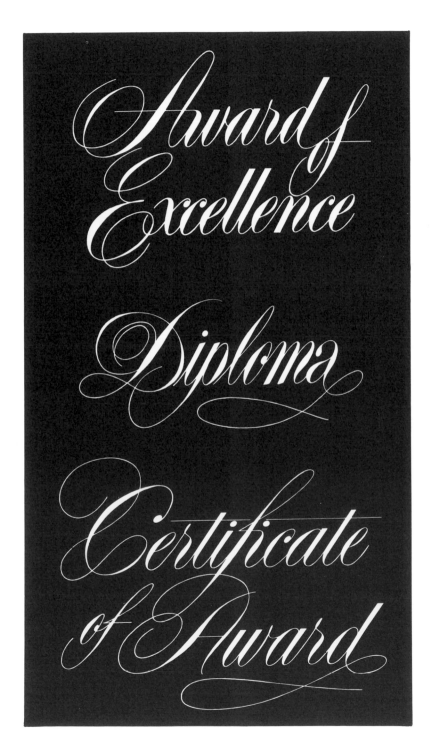

Award of Excellence

Diploma

Certificate of Award

Renaissance

This decorative letter style adds much class and effectiveness when the capitals are used for the lead initial in a paragraph or a verse.

Being very ornate and detailed, the letter must be carefully laid out on tracing paper, then transferred to the final stock for inking.

If using the broad pen, use the smallest nib and build the letter up with care.

If the art is for reproduction, the tracing should be slightly oversize. Transfer it to illustration board and do the final inking with a fine point pen. Sharpen up the art with opaque white paint and it is ready for photo reduction.

RENAISSANCE

A B C D E
F G H I J K
L M N O P
Q R S T U
V W X Y Z

Renaissance

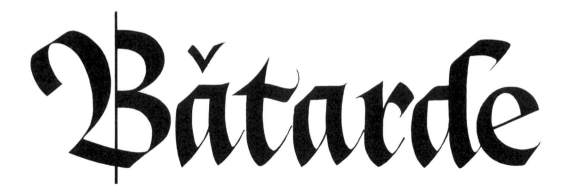

Batarde

INSTRUCTION

This beautiful angular alphabet was developed in France in the fifteenth century.

Batarde is a natural for the broad pen. It is a very angular form and the strokes are made with little difficulty. It is best to use one of the larger nib sizes to create the sharp ribbon effect. The pen is held at a 45 degree angle. The upper case letters are quite wide and contrast well with the tightly-packed lower case letters.

Batarde combines beautifully with Chancery Cursive and other italics.

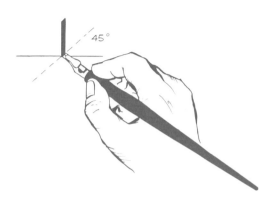

45°

BATARDE

ABCDE
FGHIJK
LMNOP
QRSTU
VWXYZ

abcdefghij
klmnopqrs
tuvwxyz

VERSALS

The name "Versals" comes from its original use as the initial letter of a verse.

Versals are tall letters with an angular grace. The main characteristic of this letter style is the gentle tapered flair curving in at the middle of the stroke. It is best to pencil in the letter shape, then use a pen width that will give you one side of the stroke, then a different pen width to create the other. After this, the space is filled in to complete the stroke. Then thin serifs are made with a flat pen angle. The letters B, D, G, P, R and U have raised and lowered loops above and below the guidelines.

V

Build up the letter with two strokes, then fill it in with pen or brush.

B

Loops rise above and fall below the guidelines.

44

ABCDE
FGHIJK
LMNOP
QRSTU
VWXYZ

VERSALS

GREETING CARDS

Greetings

Happy
Holidays
to a Wonderful
Friend

PEACE GOOD WILL on Earth toward men

Peace & Joy

...wish you a Merry Christmas

Clyde
Emma
gary

WE
WISH YOU A
MERRY
CHRISTMAS

48

INLINE

The Inline style can be strikingly effective when used as a title or as the initial capital of a word. It has great "poster punch."

The Inline technique requires some planning before its execution as the letters must be wide enough to contain the stripe comfortably. Each letter should be carefully laid out with the center line in place. One approach is to use a small broad pen and letter each side of the stroke, leaving the stripe in between. But the best technique is to letter the form completely and then carefully paint the inline with opaque white paint and a small brush. This requires precise brush control.

49

logo design

and the design of SYMBOLS

Logo design is a vital part of promotional advertising. A good logo can provide instant indentification and recognition.

The best logos are usually quite simple and symbolic. Many times the graphic symbol alone creates the company signature.

A powerful effect is often achieved by grouping stylized initials.

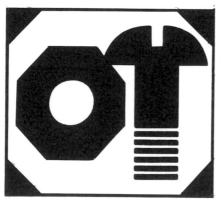

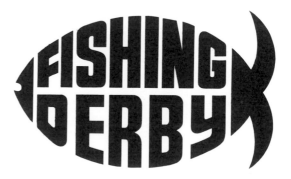

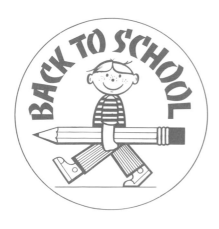

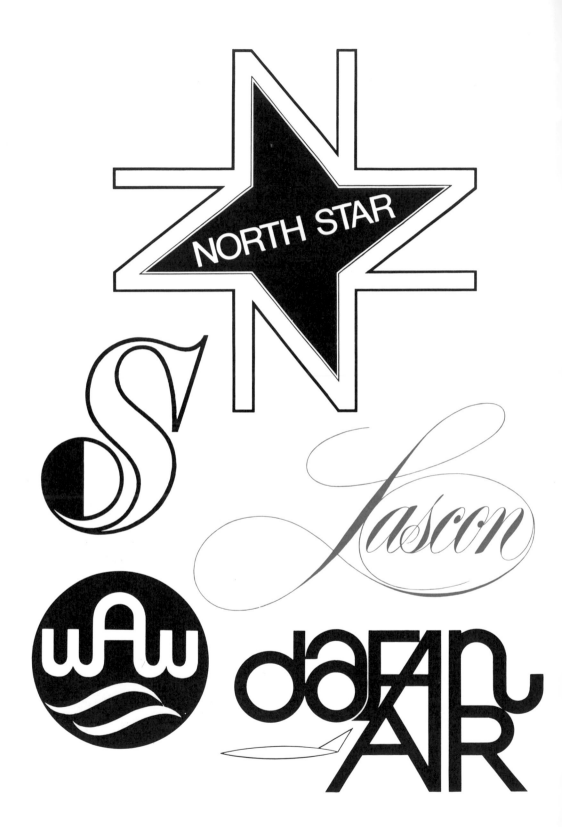

NORTH STAR

lascon

SUNGLASSES

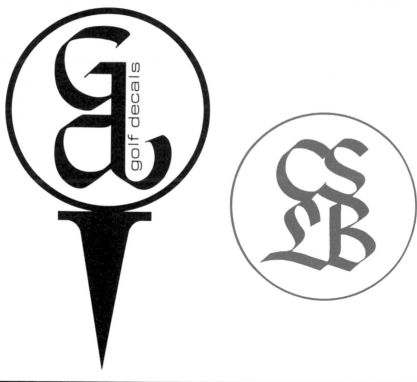

golf decals

LETTERING
WITH THE
Steel Brush

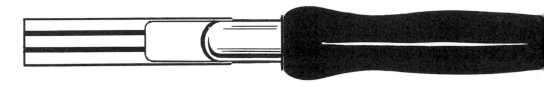

INSTRUCTION

The Steel Brush is an interesting and helpful tool. It is great for large lettering because of its extra width, and you can use thinned poster paint on it as well as ink.

Steel Brushes range from 1/4 inch to 3/4 inch wide. They make it possible to fashion letters 7 to 8 inches high.

The Steel Brush is a fine tool for sign or poster work. Try supporting your hand with a sign painter's mahlstick. The flexible tip provides more control than a brush. For interesting results, try dipping the pen into two or more colors at a time.

at work

EXAMPLES OF LETTERING USED IN ADVERTISING

QUEEN'S SPECIAL

*a*nnounces

Travel South

if your home needs a spring tonic

Latin Lovers

FAMILY - FAVORITES

coronet GRAPHICS

Pemberton Neal

Festival

California
Wine
Producers

the
VIEW
from
Olympus

Visitors
guide
and map

Harbor
House

sagittarius

continental

Gentle Care

California

Houseuares

YOU'LL SET A WORLD RECORD!

Spectacular Parade

Fun in the Sun

Beautiful women choose

IT'S EASY

CASUAL WORLD

action !

wins over all other leading cake mixes

Conclusion

It has been my pleasure to share my life-long obsession with the letter form with you. I hope you don't restrict your lettering to the broad pen. Try the fine point flexible nibs and the steel brush. Experiment with a show card brush and a sign painter's quill. These will all contribute to your total calligraphic skills. I have demonstrated many alphabets and styles; they are here for the taking. Remember, every minute you spend exploring this exciting art is yours to keep. Don't be afraid to be creative!

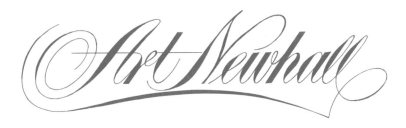

ACKNOWLEDGEMENTS

To Ross Sarracino—for his kindness and understanding.
To Sydney Sprague—for her professional help and editing.
To my wife, Emma—for her encouragement and patience.